It's OK, Feelings, I Got You

Also by Tikva Wolf

Love, Retold
Thorntree Press, 2017

Ask Me About Polyamory
The Best of Kimchi Cuddles
Thorntree Press, 2016

It's OK, Feelings, I Got You
Therapeutic Comic Drawing

Tikva Wolf

Thorntree Press

It's OK, Feelings, I Got You: Therapeutic Comic Drawing
Copyright ©2018 by Tikva Wolf

All rights reserved. No part of this book may be used or reproduced in any manner whatsoever without written permission from the publisher except in the case of brief quotations in critical articles and reviews.

Thorntree Press, LLC
P.O. Box 301231
Portland, OR 97294
press@thorntreepress.com

Thorntree Press's activities take place on traditional and ancestral lands of the Coast Salish people, including the Chinook, Musqueam, Squamish and Tsleil-Waututh nations.

Cover illustration © 2018 by Tikva Wolf
Cover and interior design by Jeff Werner
Proofreading by Roma Ilnyckyj

Library of Congress Cataloging-in-Publication Data

Names: Wolf, Tikva, author.
Title: It's ok, feelings, I got you : therapeutic comic drawing / Tikva Wolf.
Description: Portland, OR : Thorntree Press, [2018]
Identifiers: LCCN 2018025528 | ISBN 9781944934712 (softcover)
Subjects: LCSH: Arts--Therapeutic use. | Emotions in art. | Comic books, strips, etc.--Psychological aspects.
Classification: LCC RC489.A72 W64 2018 | DDC 616.89/1656--dc23
LC record available at https://lccn.loc.gov/2018025528

10 9 8 7 6 5 4 3 2

Printed in the United States of America on acid- free paper that is certified by the Forest Stewardship Council® and the Rainforest Alliance

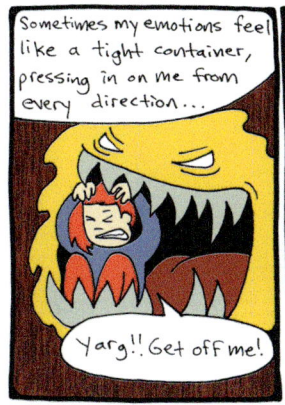
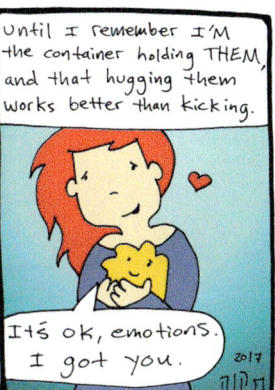

To Brian Adler, who helped me practice and hone my self-inquiry process and who inspires me to always be curious about what I'm hiding from myself. To Mark Runge, for encouraging me to think outside of all the boxes as an artist, and to keep looking for new ways to "paint with flowers".

PART 1: BACKGROUND	**1**
PART 2: METHOD	**11**
PART 3: CURIOSITY AS A TOOL	**25**
PART 4: SHARING WITH OTHERS	**31**
PART 5: SHARING WITH KIDS	**35**
PART 6: COMICS FROM WORKSHOP ATTENDEES	**43**
PART 7: COMIC METHOD SUMMARY	**53**

PART 1: BACKGROUND

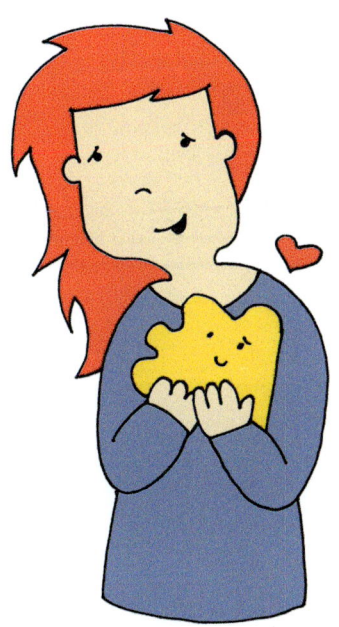

It's even helped me see the secret layers that are underneath, that I was hiding from myself. This helps me notice what I REALLY need in those types of difficult situations.

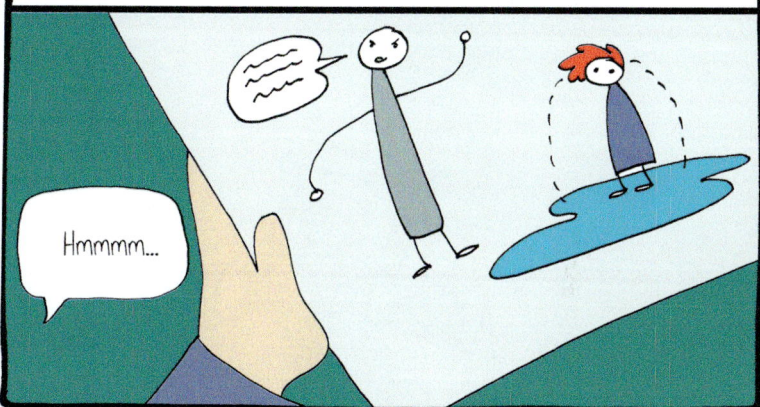

This is part of what led to the creation of the Kimchi Cuddles universe, which is a comic series about interpersonal dynamics in various sorts of unconventional relationships.

The personal experiences I wrote about in Kimchi Cuddles resonated with a lot of people, and I started sharing my drawing method in a workshop called "Therapeutic Comic Drawing".

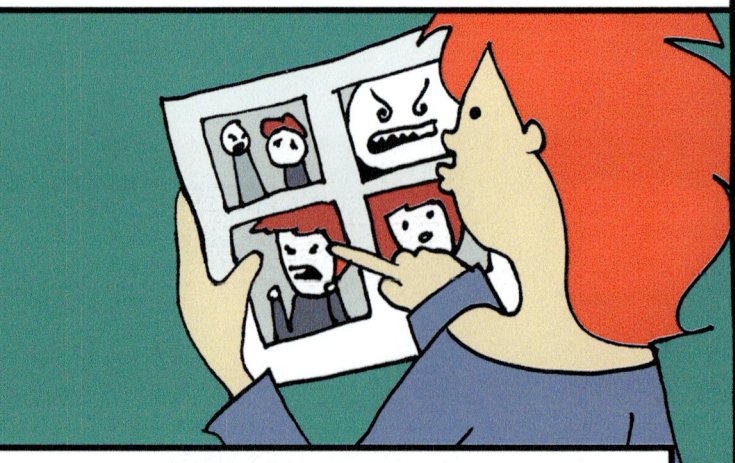

Different types of meditation and reflection practices are useful in different ways, because they approach the same experiences from different angles. Being a visual meditation, this method can illuminate hidden aspects of the experience that are sometimes very surprising!

Whoa, I hadn't realized how these two things were connected, but seeing them on the page next to each other, it makes more sense!

The Therapeutic Comic Drawing workshop walks people through the steps I go through myself to visually process emotions, and this book was written to do the same. It is not meant to replace therapy but can be an excellent supplement to other practices, including psychotherapy, grief, and 12-step work.

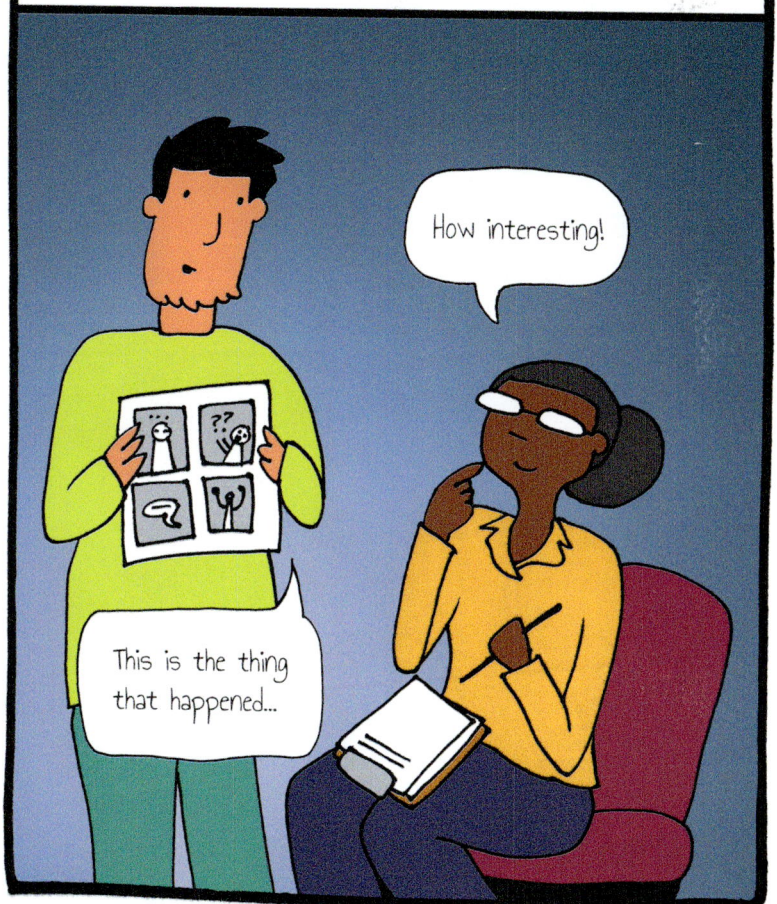

When I was a kid, I felt like I didn't have anyone to talk to about some really difficult things going on in my life. I didn't even know how to start. But I loved drawing, so I started making secret comics depicting my difficulties and how I felt about them.

As a result, I noticed 3 very important things happen:

- I felt heard.
- The difficult event felt easier to digest.
- I was able to see the whole situation more clearly.

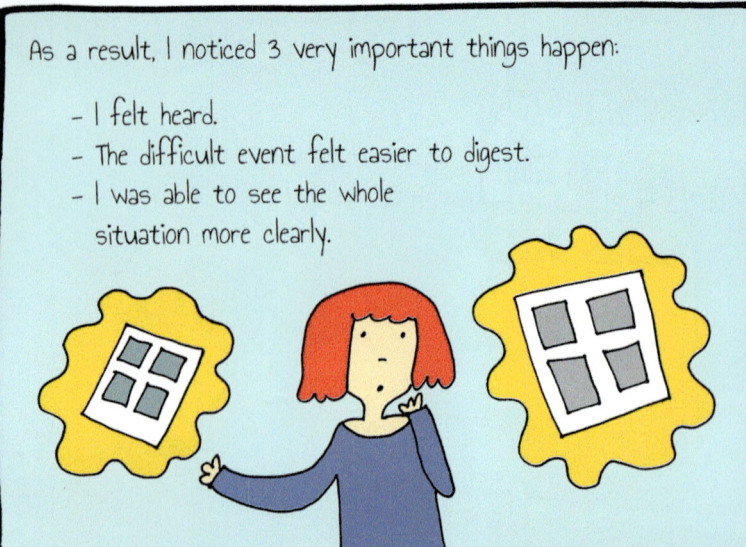

Just by drawing the upsetting event, I was creating a visual representation of my thoughts, which allowed me to both express my emotions and be my own witness for them. I felt heard, even though I was the only one doing the listening.

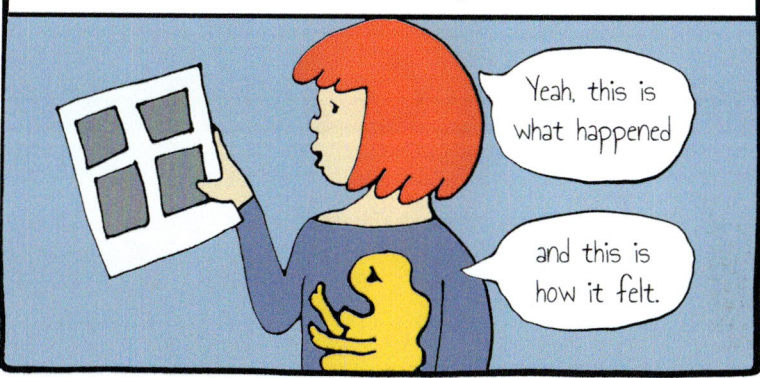

So even though I hadn't shared my comics with anyone else yet, I felt a little better just because I'd allowed myself to listen to myself, believe myself, and hold the space for what that little emotions monster inside of myself had to tell me.

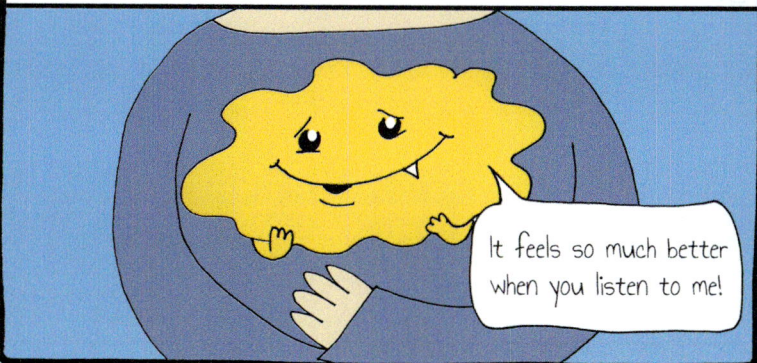

In addition to feeling heard, I noticed that the situation itself suddenly seemed a lot easier to digest. By taking these huge, overwhelming emotions and putting them on a little piece of paper, I was able to hold the space for those emotions.

Just being able to put an overwhelming event on paper and hold it in your hands can feel incredibly powerful. It is an immediate visual reminder that I'M the one holding my emotions, not the other way around.

"I got this."

The 3rd thing I noticed was that I was able to see the whole situation more clearly, because I was literally taking a step back from the whole thing in order to be able to draw it. I'd often add an element of humor to the situation and exaggerate the event in order to capture the intensity of my feelings.

Interestingly, making a comically exaggerated version actually helped me see the situation more clearly and notice pieces that I hadn't noticed before. Instead of feeling overwhelmed or hopeless, I felt empowered to look for the options I hadn't even discovered yet. Cultivating that curiosity has given me a strength and clarity that stays with me even in the most difficult moments.

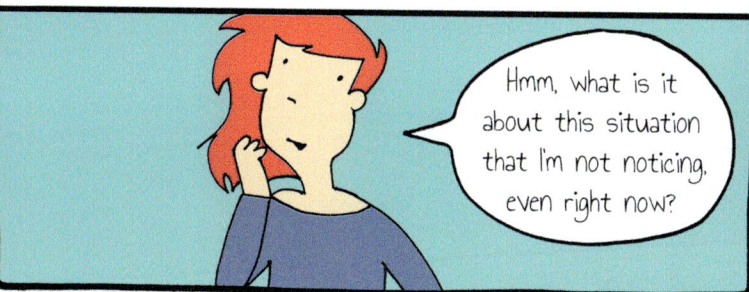

PART 2: METHOD

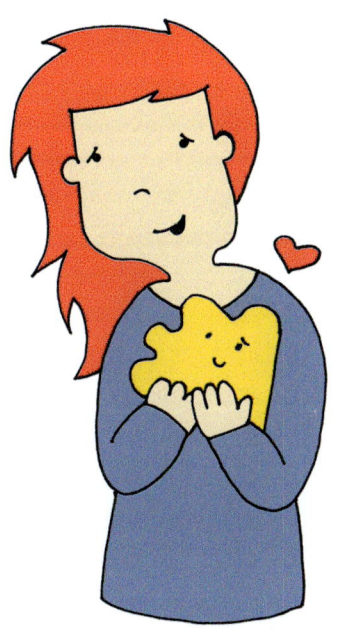

It doesn't matter what it looks like. You're drawing for you, not for someone else. And if there's a someone else who would tell you you're doing it wrong, we can draw that person with a weird scribble face to get our horrible artistic revenge.

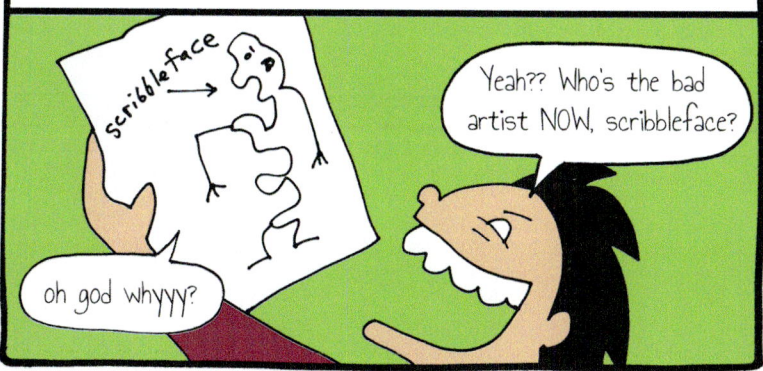

But seriously, stick figures are fine. And if you can't draw a stick figure, any shape representing a person is also fine. If you can write words with a pen, you can create shapes on paper! People can even be represented with letters if that feels easier.

To start, take a piece of paper and divide it into 4 sections. You can draw 4 different comic squares, or you can just draw 2 lines across the page in either direction to create 4 sections:

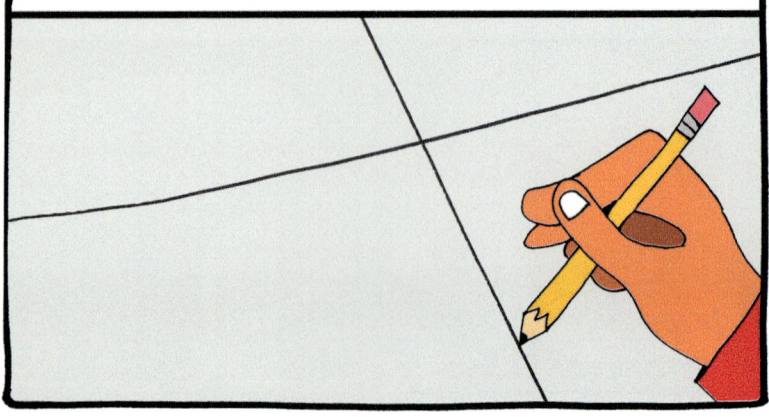

The first panel is going to depict a THING THAT HAPPENED. You might have something in mind already, or maybe not. But before you start drawing, take a moment to get in touch with the feelings you have in your body right now. I find it helpful to put my hand on my stomach or chest to notice the sensations there.

My stomach feels tight and my shoulders are really tensed up. What's that about?

When noticing the actual feelings in your body, there might be words, images, or associations that come to mind already. If you have a situation that you want to explore with this exercise, then you're ready to draw! If you aren't upset about anything currently, you can explore something that you're chronically upset about, or something from your past that you hold on to.

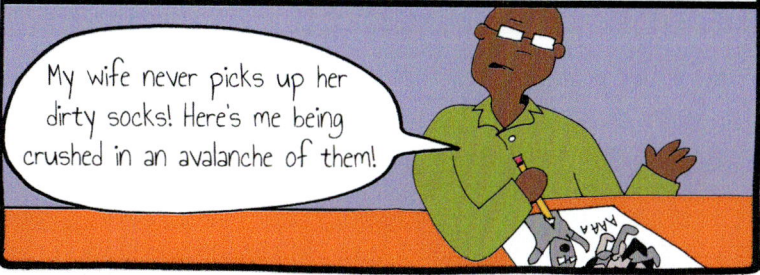

When you depict the situation in question, don't water it down or be polite about it. We want the RAW UNEDITED version of what you're upset about. We want to know what your ACTUAL experience is. What does it look like? What does it feel like?

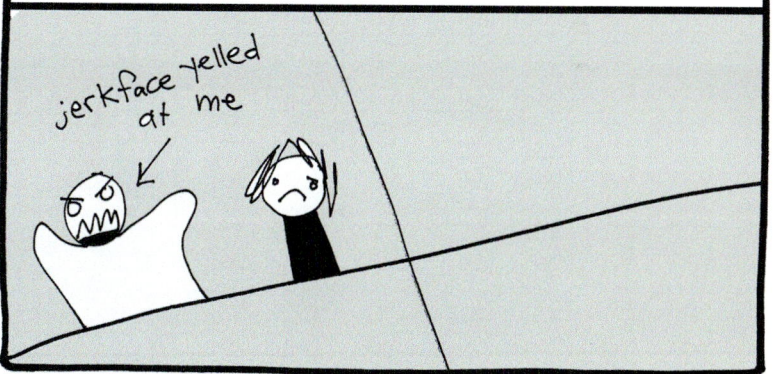

So the first comic panel depicts WHAT HAPPENED. The 2nd panel depicts your REACTION to it. This could be external (something you actually did in response) or internal (your emotional reaction).

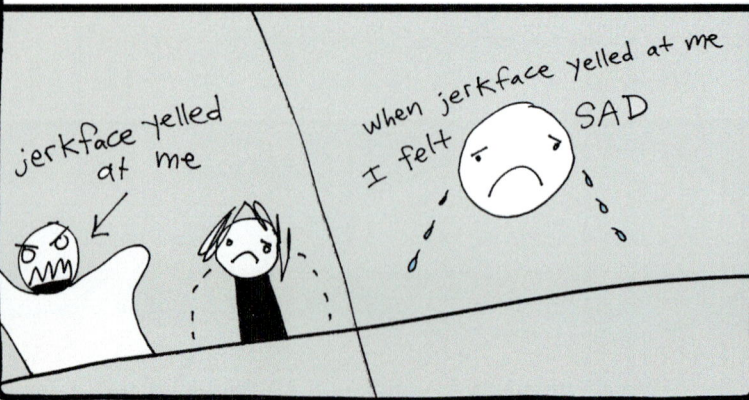

Sometimes our reactions can be quite complex, and there can be a lot of value in noticing the layers that are underneath our surface reactions. I notice that when I react with anger, I'm often covering up the self-aggression and shame that are hidden in a secret layer underneath that angry outer layer.

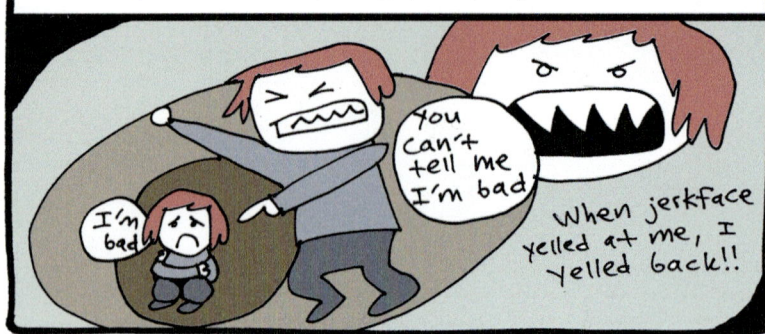

This is the beginning half: the situation and the reaction. Before we move on to the next 2 panels, pause a moment to really take in what you've created so far. Being your own witness and holding space for these emotions is an important part of the process. One useful question you could ask yourself in this moment is "When is the first time I can remember something like this happen?".

> Wow, I didn't think it was related, but this is actually the same exact feeling I had when my dad yelled at my mom. What's THAT about?

Now look at the first 2 panels and imagine that SOMEONE ELSE wrote this comic and handed it to you asking for sage advice. You are your own wise friend, and you have all the answers. Some people (like me) find it helpful to create a different character to depict their wise self, to relieve the pressure of "needing to know something" while also surrendering to the possibility that wisdom is available to all of us in every moment we are open to listening.

> Hey self, can you take a look at this?

My Therapeutic Comic Drawing workshop attendees have come up with some amazing images of their wise inner selves. Among my favorites are: a jar of playdough, a shimmering orb of wisdom, their child self, a happy blob of happiness, and a cat.

Actually, this is how the nonbinary character Marco originated in the Kimchi Cuddles comic universe, because they were my own wise self who had the answers that I didn't feel confident enough to have at the time, including understanding my gender identity.

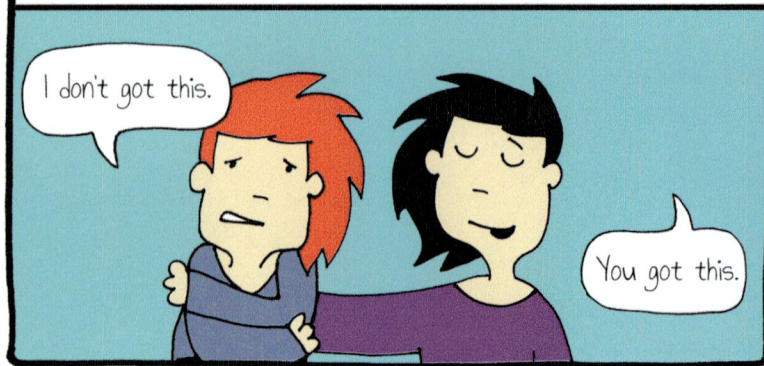

So when you're ready, receive the first 2 panels of the comic as if someone else is asking you advice through them. What is it that this person might be asking for? What is the underlying issue that maybe isn't being given a voice yet?

You can use the 3rd panel to depict this question, coming from either you or your wise self. When this event (panel 1) happens, what is it that you most deeply want or need in that moment?

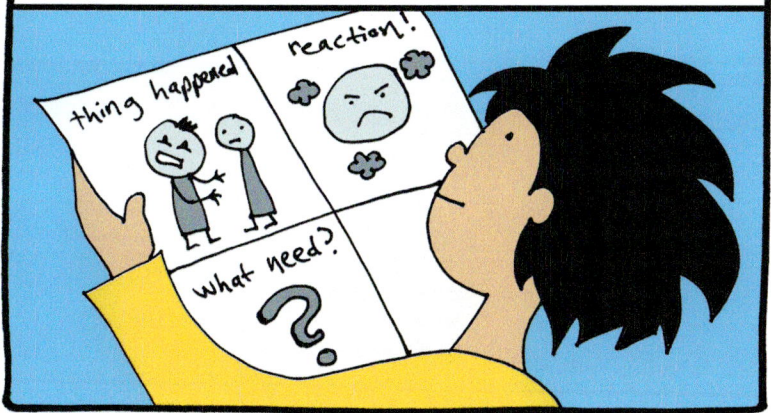

Now here's the part that might be tricky if you're prone to self criticism. Your wise self isn't going to tell you something that feels bad or shameful. It might seem like the "correct answer" to panel 3 is something that you think you SHOULD be doing or experiencing other than what you actually did in panel 2.

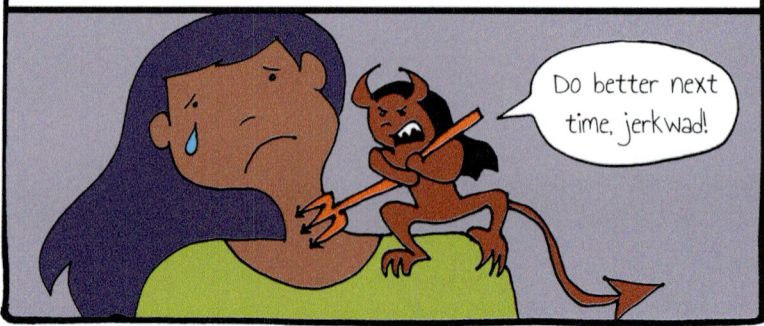

But that inner critic isn't your wise self. Your wise self is way deeper down. It's the little monster that's been yelling in the pit of your soul the whole time but needs you to give it a hug before it can tell you something intelligible or useful.

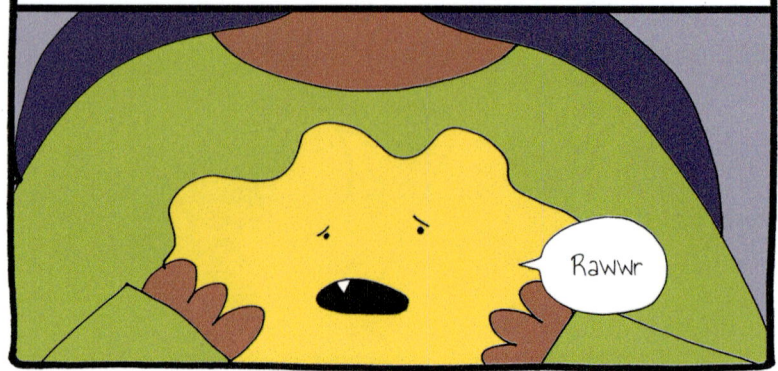

The answer in panel 4 will come from accessing that little feelings monster and giving it what it really needs. The little monster is your deepest self that you hide from yourself. What is it that the little monster needs? Go ahead and ask.

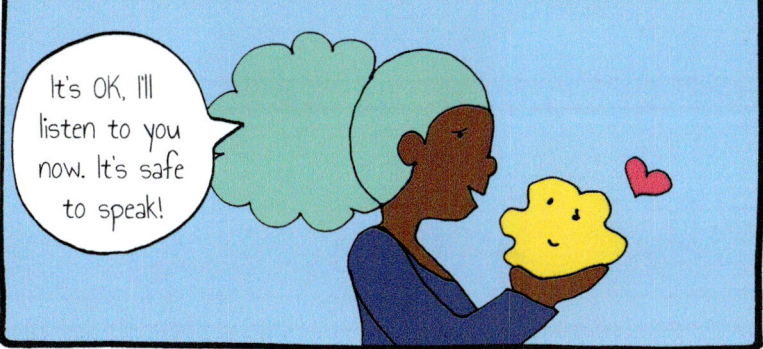

The answers to the most difficult questions in life all come from letting that part of yourself have a voice, and holding space for what it has to tell you. It's a part of you that you were taught to quiet down as a child, and it might be difficult to access at first. Some people find it easier to let that part of themselves answer by writing with their non dominant hand for the 3rd panel.

Letting that little monster or inner child have a voice might reveal some really surprising answers! Understanding that voice is what gives you access to your true wise self. Your wise self is like a loving parent to that inner child. Maybe one that they never had.

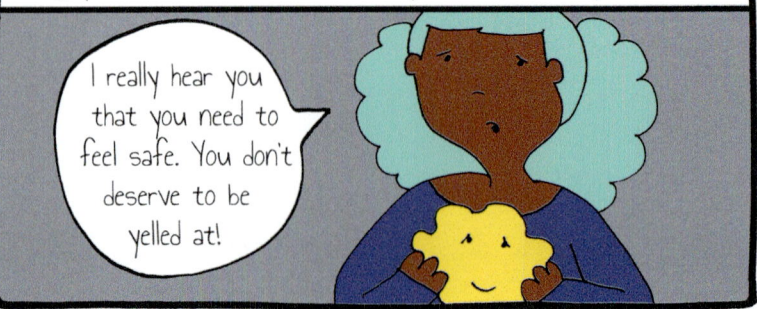

When you're ready, draw panel 4. It depicts the answer you have to the question you asked yourself in panel 3, or the way to meet the unmet needs that were brought up in panel 3. You are both the little emotions monster AND the wise self that knows how to care for it all wrapped into one. You have the question, and you also have the answer to that question.

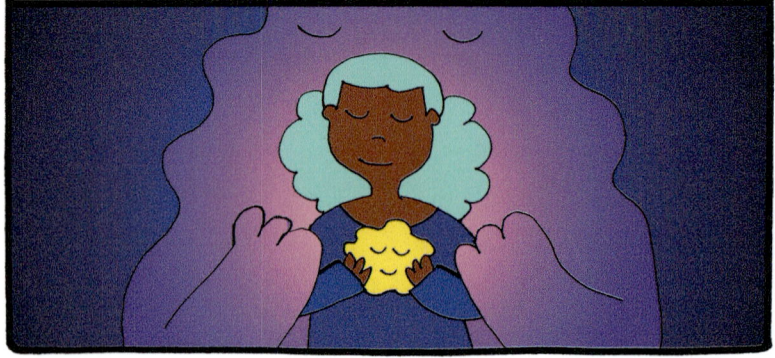

The final panel can also include examples of actions you might take in similar situations in the future, which can be alternative reactions to what you depicted in panel 2. Ask yourself: When panel 1 happens, what are some actions I can take that would best result in me actually getting my needs met (specifically the secret underlying needs that I have discovered in panel 3)?

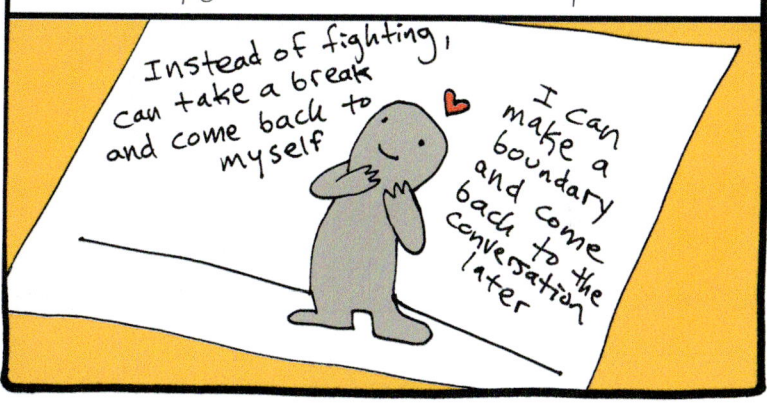

You can use this method in a multitude of ways, ranging from acute to chronic issues. There's always a hidden layer underneath the ones we have the easiest access to.

PART 3: CURIOSITY AS A TOOL

Honoring your own reality is important, and I find that holding my thoughts with curiosity rather than conviction actually strengthens my ability to do that. It sounds counterintuitive, but when I replace an exclamation mark in my brain with a question mark, I notice a lot of details I'd been ignoring before.

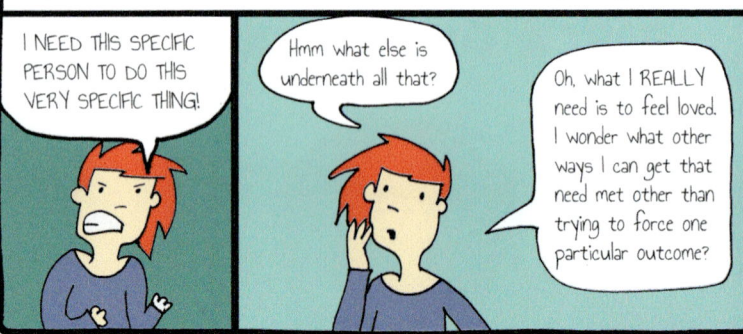

I NEED THIS SPECIFIC PERSON TO DO THIS VERY SPECIFIC THING!

Hmm what else is underneath all that?

Oh, what I REALLY need is to feel loved. I wonder what other ways I can get that need met other than trying to force one particular outcome?

Approaching panels 3 and 4 with that kind of openness and curiosity has led me to some truly transformative revelations about how I lead my life and what alternative options I have available to me whenever I'm not hyper-focused on just one.

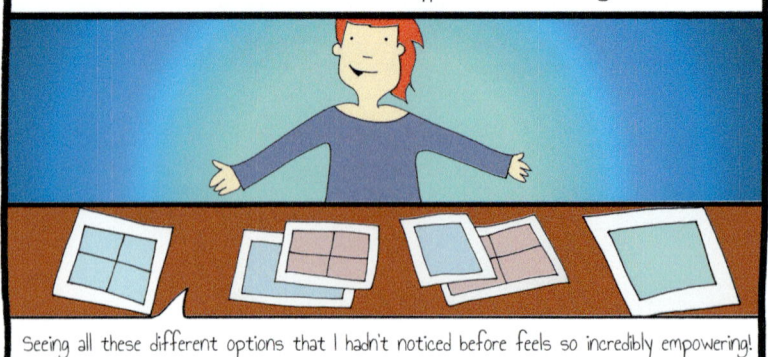

Seeing all these different options that I hadn't noticed before feels so incredibly empowering!

If questioning your reality sounds harmful, DON'T DO IT! That's just gaslighting yourself and suppressing your emotions, which can be incredibly harmful. Likewise, don't listen to anyone who gave you this book to "fix" you. Everyone's journey is personal and should bring you closer to what your deepest truths are.

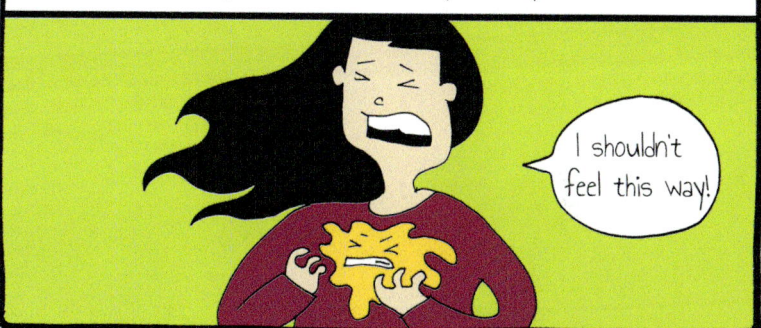

There's a subtler way of questioning that actually gets you MORE in touch with your truth, because you're digging deeper down rather than trying to talk yourself out of something. Before being curious about what's underneath, it's important to hold space for the feeling and acknowledge it as real.

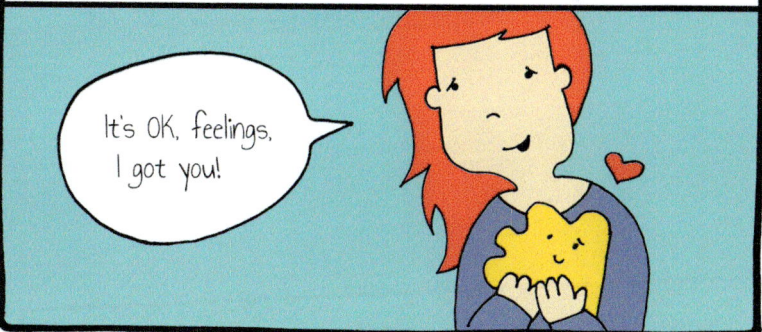

Fighting feelings at the surface:

I feel sad, but I shouldn't, so I'll tell myself NOT to feel that way!

Now I feel even worse!!

Digging deeper:

Hmm, what's inside me telling me that I shouldn't feel sad? Is it possible that it's OK to feel sad even if I don't understand why? If the sadness was able to talk, what would it tell me?

Are you ready to listen?

We already know what's true deep down, but we cover it up by getting fixated on the specifics of the situation and all our thoughts about it. When we are able to approach the whole thing with a more curious attitude, we have more access to the deeper truths underneath the details covering them up.

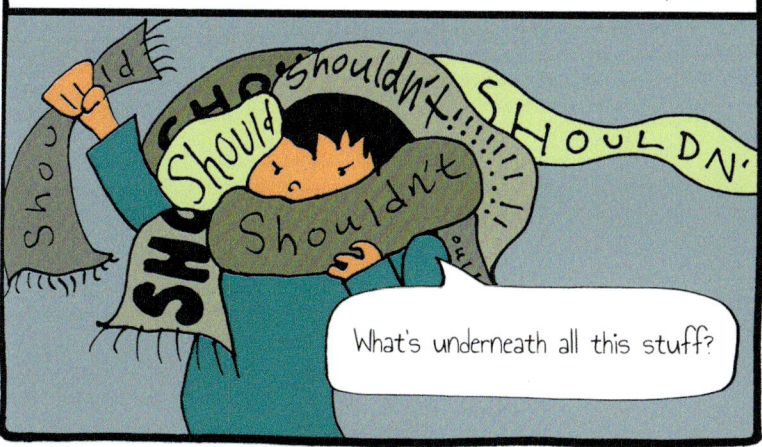

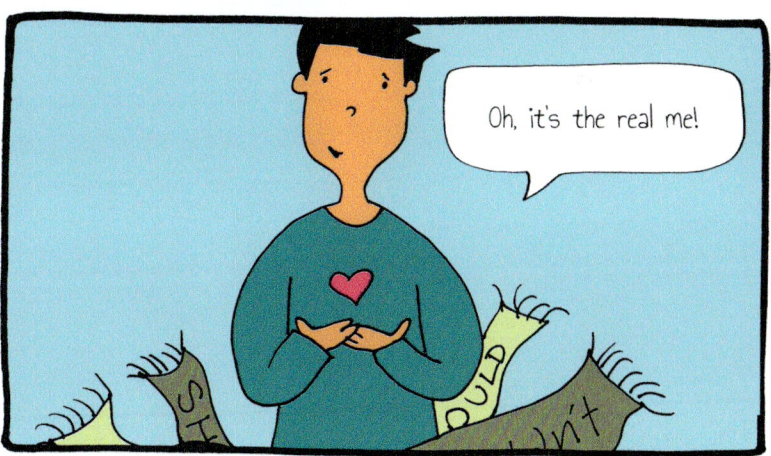

PART 4: SHARING WITH OTHERS

You might want to make these comics just for yourself, or you might want to use them to explain your experiences to others. Images can be a powerful way of conveying emotions and ideas in a way that's easier to digest, without as much of a chance of misinterpretation. If you say the words "I felt upset", any number of "upset" images might come to mind for someone else.

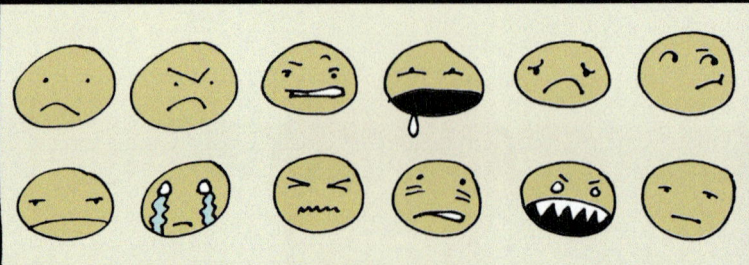

But when you draw your experience, you don't even need to figure out the exact words to explain it. It's often easier to empathize with a scribble of an emotion than with someone's description of it, partially because the focus is on the person's actual experience rather than arguing over who to blame for it.

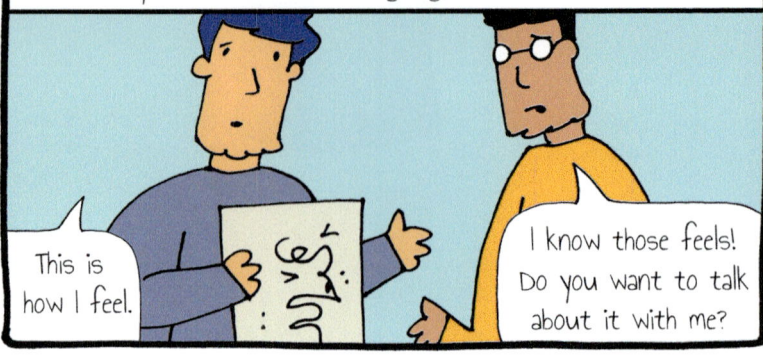

If you do share your comics with others, be sure you're ready to receive feedback! Someone might disagree with your depiction of the situation because they experienced it differently. This can feel very upsetting if you want to feel heard and understood.

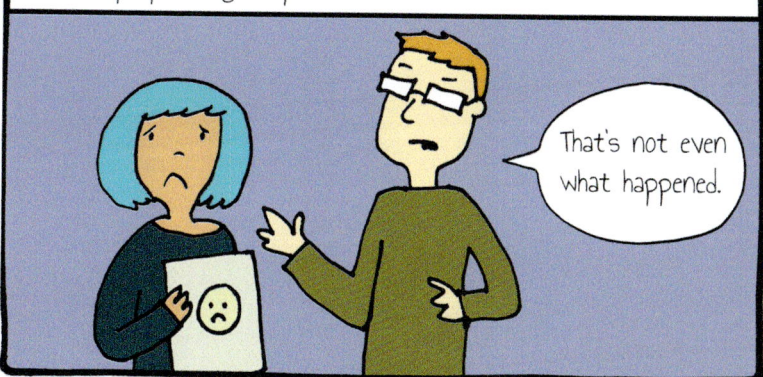

We can't control how other people experience reality, even if we draw the most amazingly vulnerable comics about it. So remember to take care of yourself and give yourself what you need (see panel 4). Taking care of yourself might look like sharing these comics only with people you know you can trust to value your experience, or with a therapist or 12-step sponsor.

PART 5: SHARING WITH KIDS

This method can also be an amazing tool for parents if it's used as a game rather than a structured process. It's important to remember that when you're sharing with kids, you're using this method ONLY to be more vulnerable yourself, NOT trying to get them to have a different experience or change their behavior.

It's very important to remember the inherent power imbalance when interacting with children. You DON'T want to encourage them to question their reality. Rather, you can use this game to more deeply empathize with THEIR experience and understand things from their point of view. My daughter and I came up with a fun new version that we started sharing when she was a preschooler, simply called "drawing feelings", and still do it today!

I introduced the idea to her during a moment of power struggling about putting on socks. After initially going into the habit of angrily trying to force her to comply, I switched gears and said:

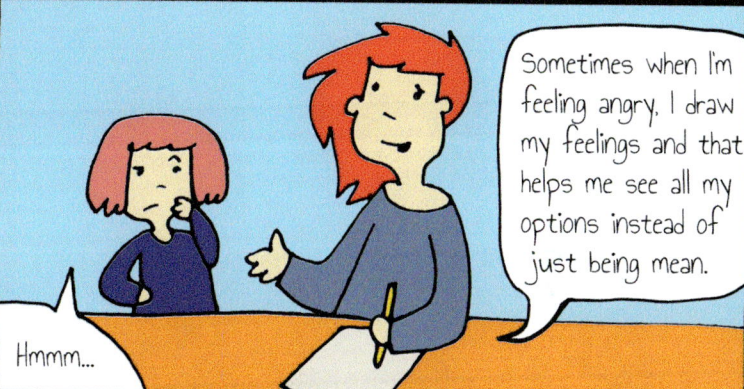

Sometimes when I'm feeling angry, I draw my feelings and that helps me see all my options instead of just being mean.

Hmmm...

She was very curious to see what that looked like. Instead of continuing to power struggle about socks and whether or not they are evil, she watched me draw my feelings and actually take responsibility instead of blame her for my own emotional reaction.

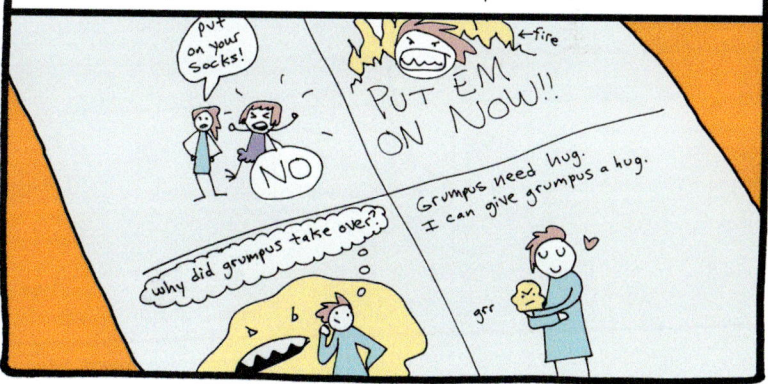

If I was giving my grumpy feelings a hug, I wouldn't need to be grumpy at you when you're resisting socks. I know it might be frustrating how grown ups always tell you what to do!!

I still want you to put on socks before we go, but I can say it with love instead of anger.

OK now my turn!

This is what it means to detach with love. You are still able to be emotionally present, but you don't feel the need to get all wrapped up in the drama of the moment!

Without trying to get her to do it, she started drawing HER emotions and sharing with me too! It's a game we still share today, and it's been a valuable tool to help me empathize with her experience.

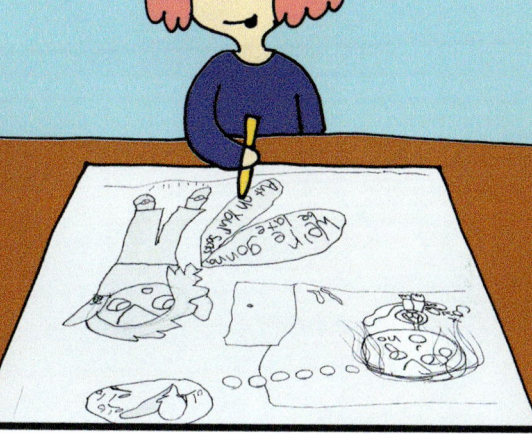

If you try to share this game with children, notice if you're playing with an agenda or for the sake of the exploration. It's all fun and games until we forget it's all fun and games! Keep open access to curiosity when kids are involved.!

It can be hard to remember that a kid's emotions matter, especially when they're yelling about something that seems completely unimportant (like getting another cookie).

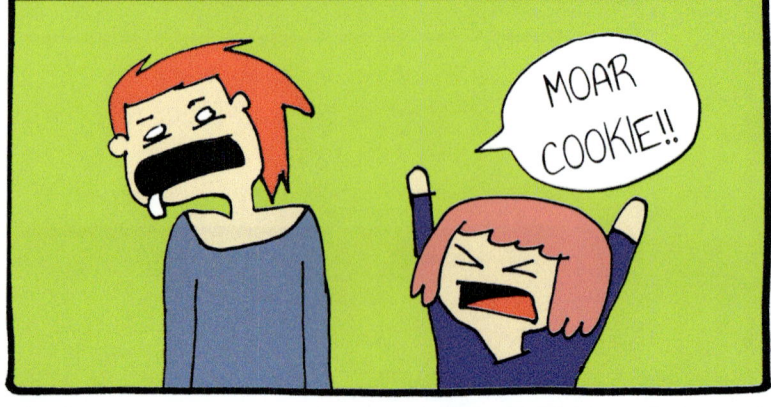

But really, it's never even about the cookie. Kids just want to feel heard and respected about their emotions (pro-tip: so do adults).

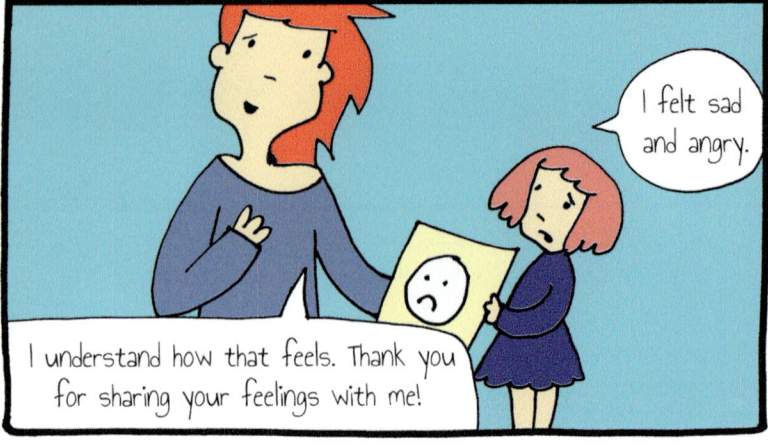

One of the most valuable parts of sharing this practice with my daughter is actually just the inherent pause from tension that comes with it (because we both stop interacting for a moment in order to draw). That in and of itself gives us both a moment to cool down and have more of a chance of listening to each other afterward. Also, we both already feel a bit heard after drawing, just from being our own witnesses while drawing.

And expressing our feelings more vulnerably to each other is always better than trying to BE RIGHT at each other in anger. Sharing this visual practice has helped us trust that the other will listen when we are vulnerable and wanting to feel heard.

PART 6: COMICS FROM WORKSHOP ATTENDEES

The following pages contain some example comics from my "Therapeutic Comic Drawing" workshop attendees.

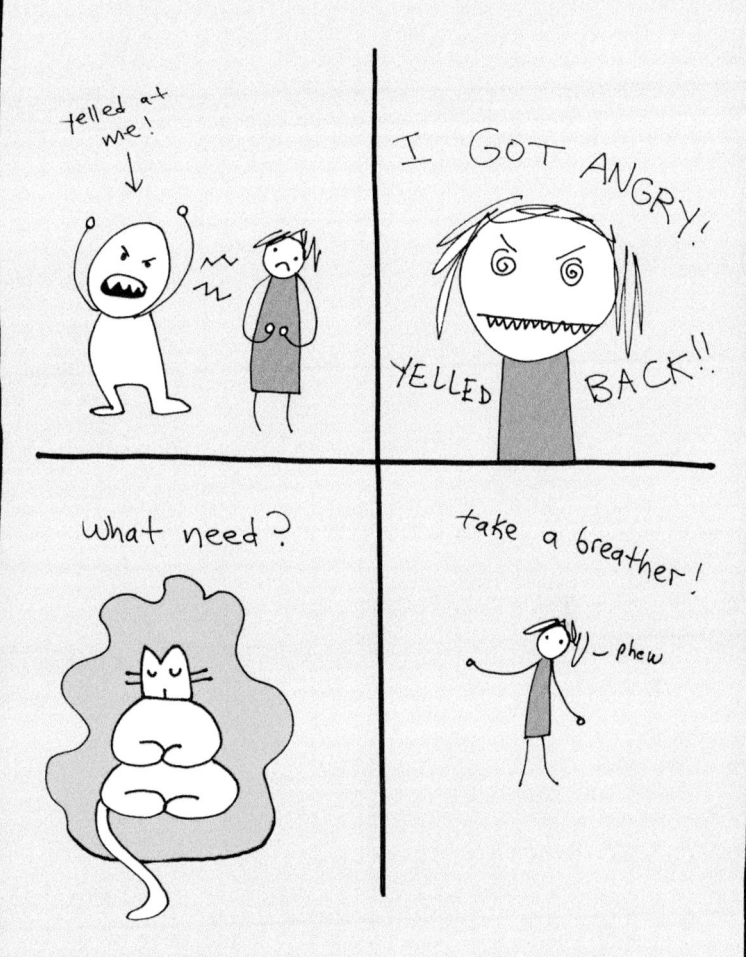

Notice how this workshop attendee chooses a cup of green tea to represent his "wise self". In the first panel, he is anxious about being somewhere on time. In the 2nd panel, he reacts by trying to relax (perhaps suppressing the anxiety), which results in "freak out". In the 3rd panel, Ms. Green Tea is asked for help about the anxiety, and in the 4th panel she suggests that he IS able to relax with the aid of something soothing and seeking professional assistance.

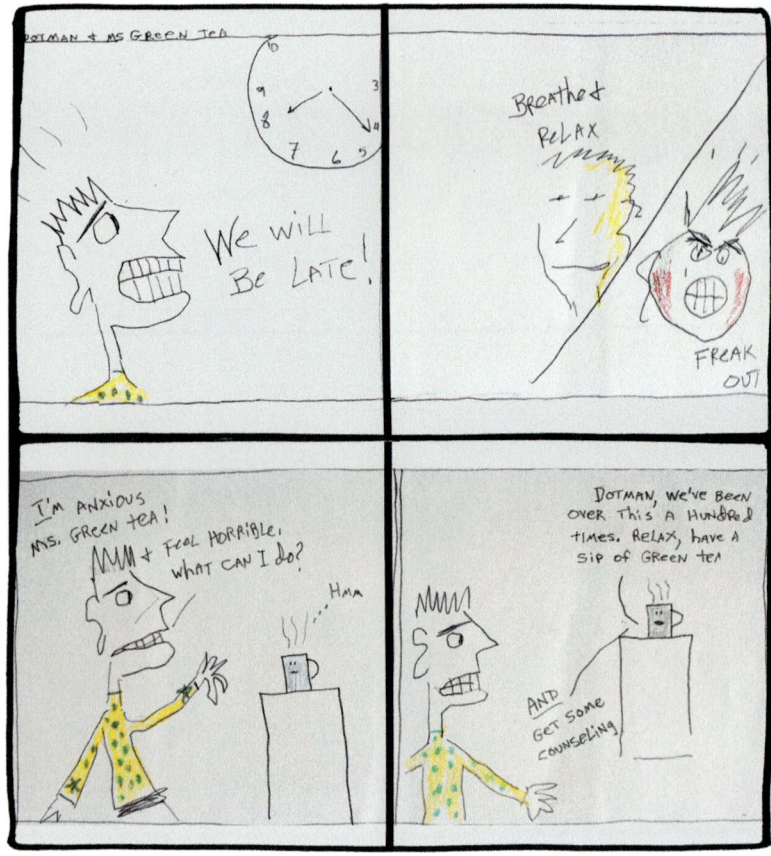

This attendee explored her reactions to others trying to control her behavior, which was an internal progression of sadness, anger, resistance, and quiet dissociation. Her "wise self" is shown as loving parents ready to give compassion and acceptance to the scared inner child self. In the 4th panel, she has become the integrated version of inner child and wise self, shown as holding the loving parents within her own psyche and giving herself the permission to "do and say what I want to".

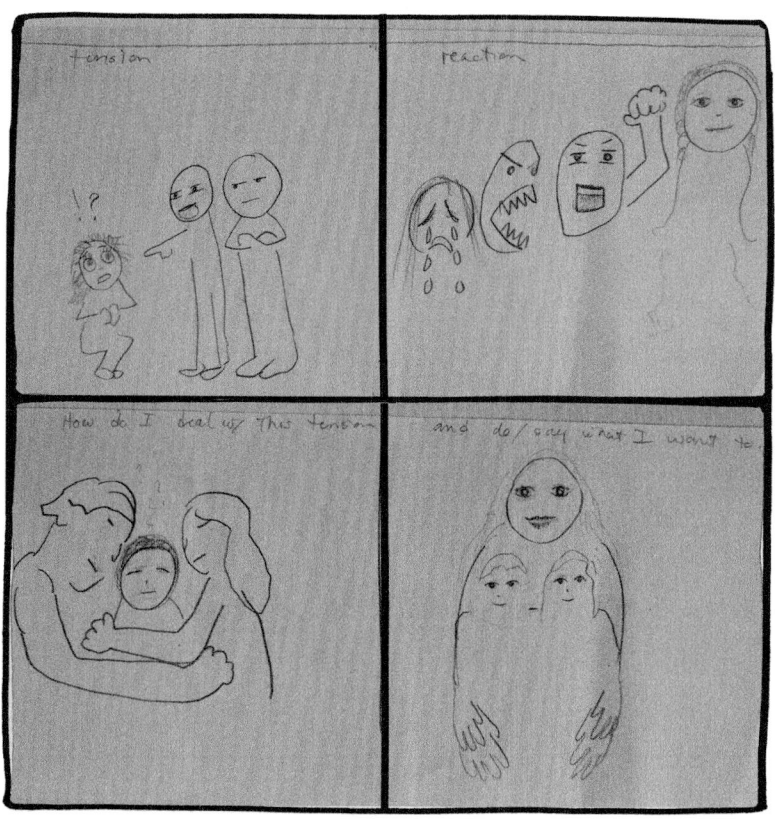

This attendee had a creative journey to explore why their newfound lack of financial stress had been causing them MORE stress. They discovered that they'd been having an attitude of scarcity/hoarding with newfound wealth, and that they felt better with the idea of living simply and appreciating the opportunity to get out of debt.

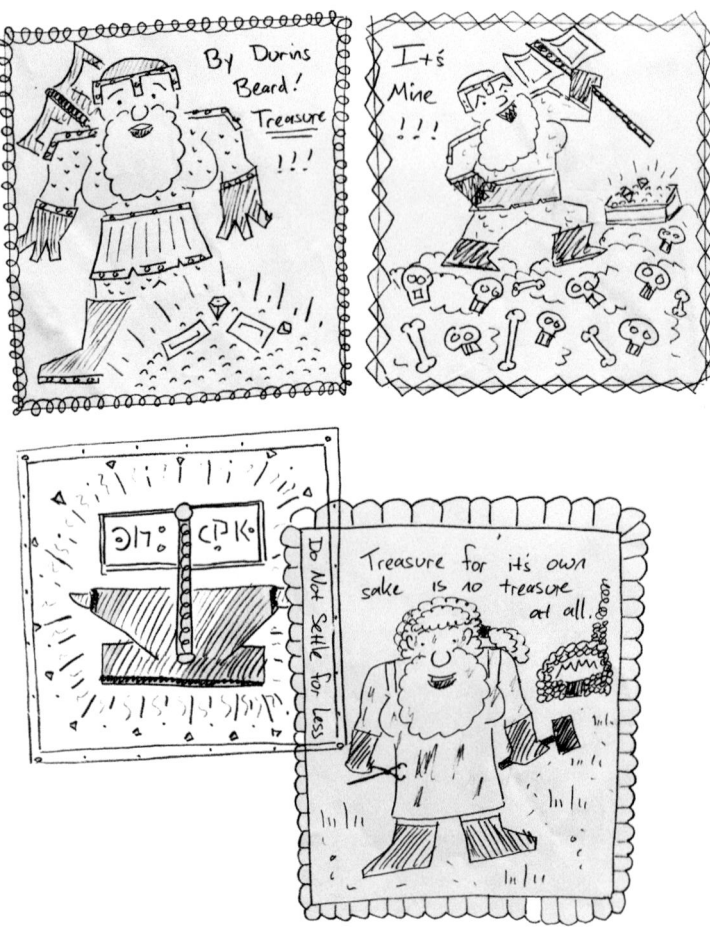

This attendee's wise self shows them that what's underneath the fear of rejection is actually their own heart full of love.

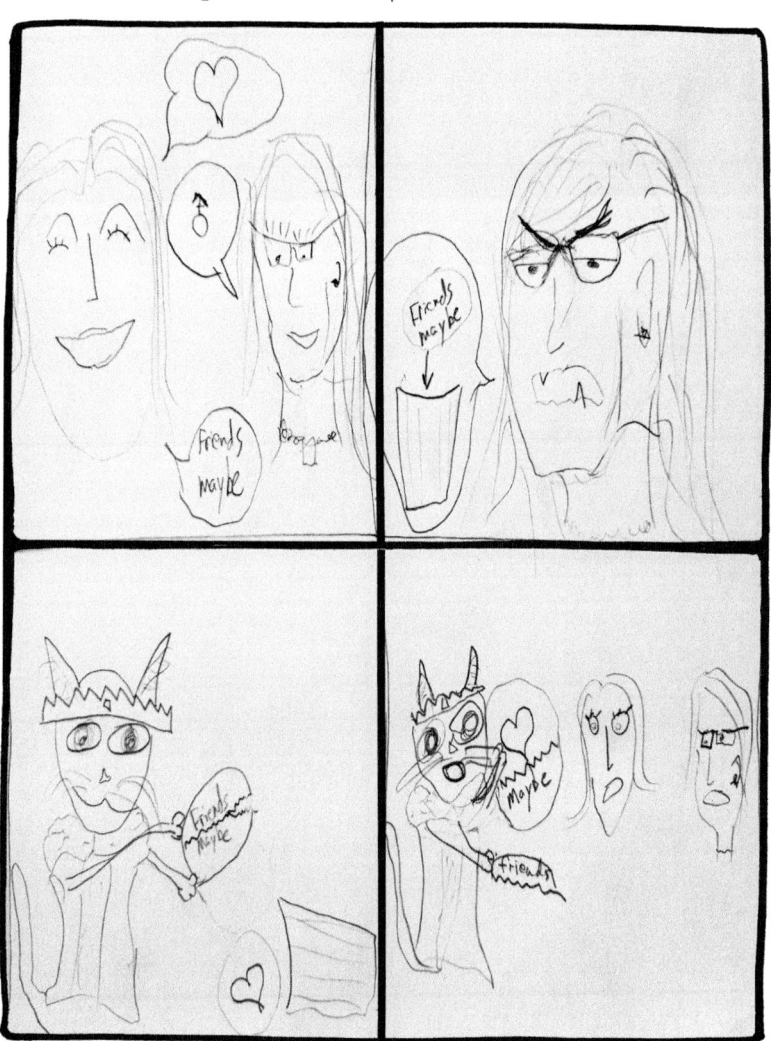

This attendee's wise self offers them a multitude of options when they are feeling guilty about the loss of a loved one.

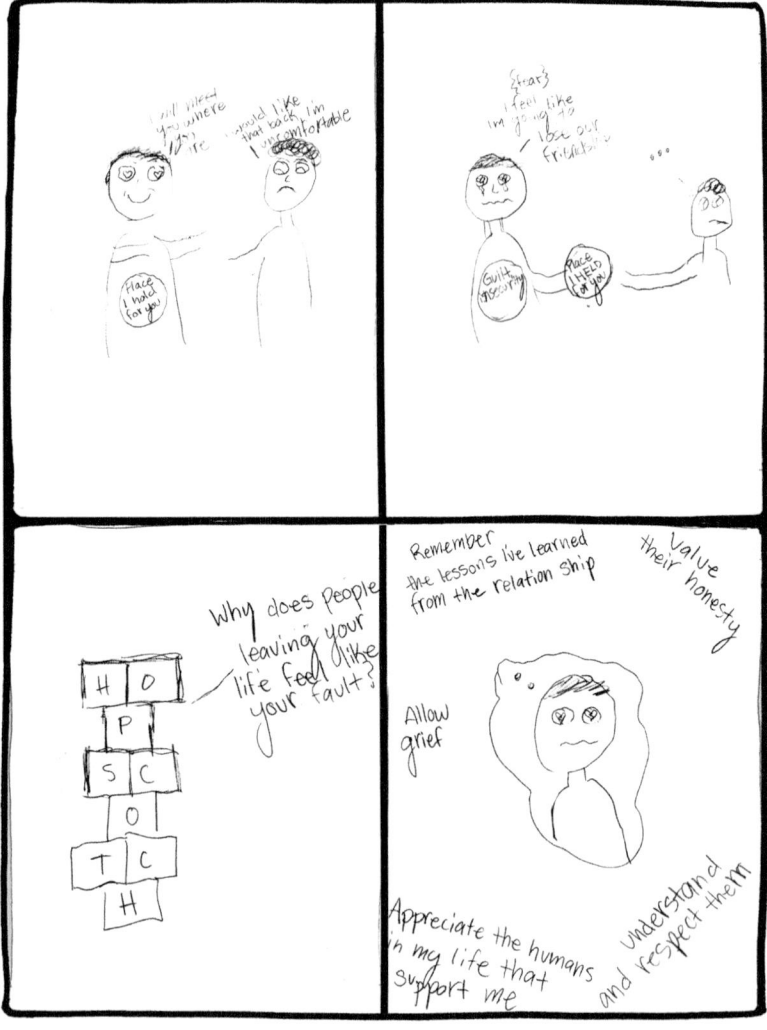

This attendee discovers that even through all the sadness and confusion of divorce, they still trust the path they're on.

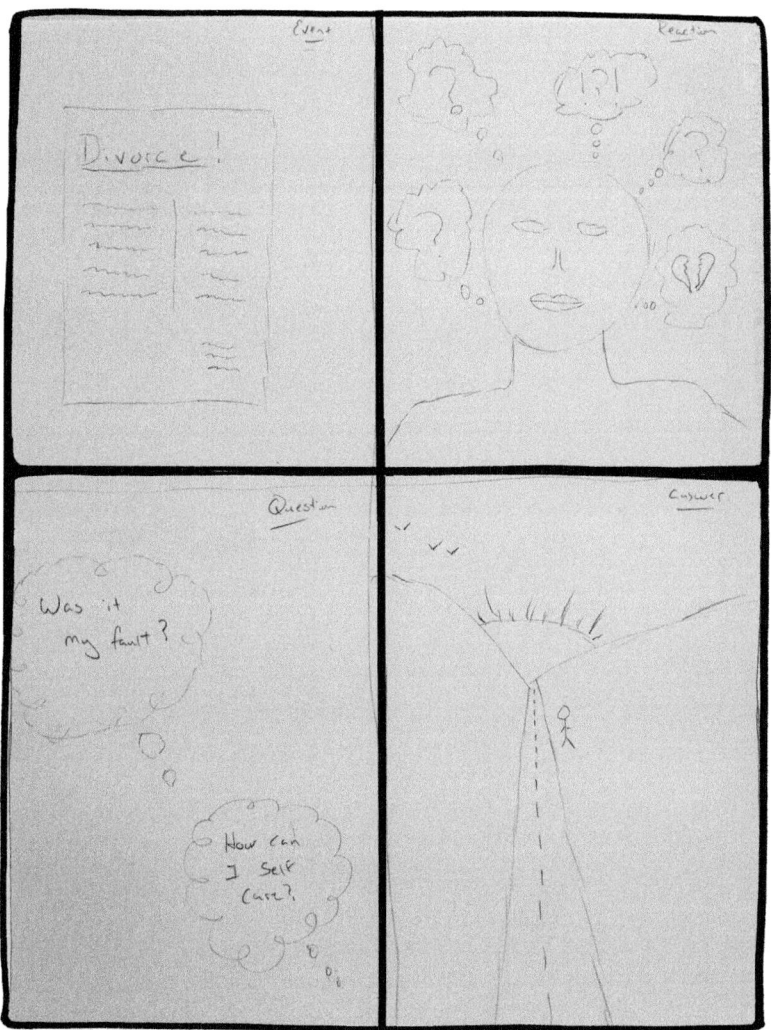

PART 7: METHOD SUMMARY

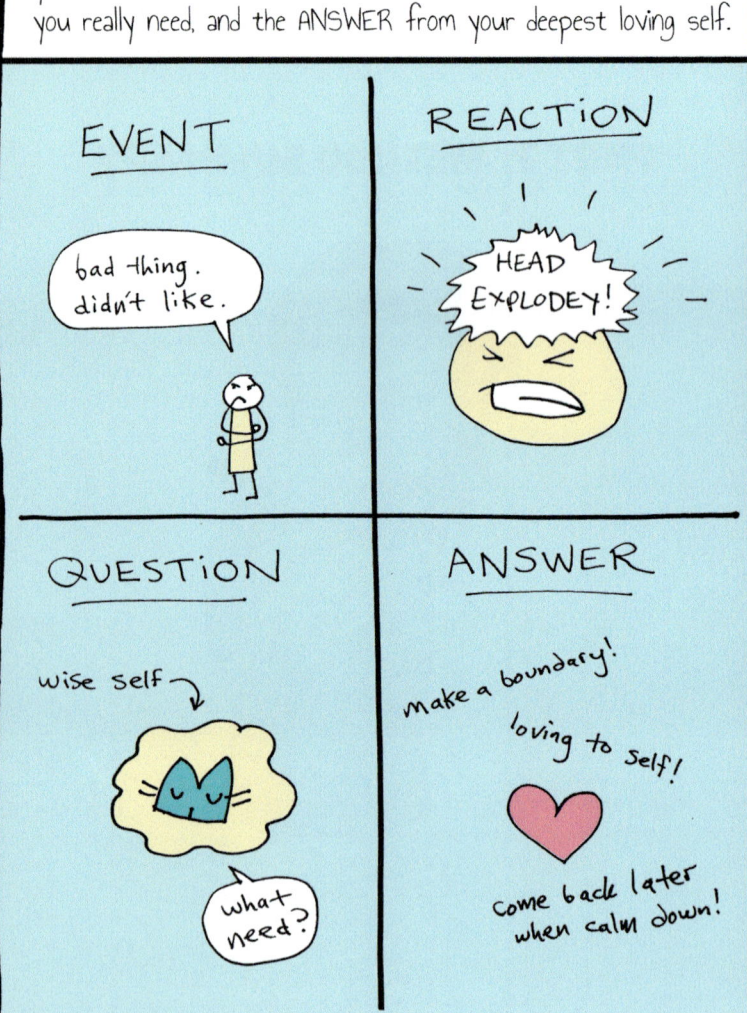

Also from Thorntree Press

*Ask Me About Polyamory:
The Best of Kimchi Cuddles*
Tikva Wolf, 2016
"A warm-hearted, wise, and brave comic: an invaluable resource in the global polyamory movement."
—Dr. Anya, author of *Opening Love*

Love, Retold
Tikva Wolf, 2017
"For wistful adult readers who meditate on their own past loves and what could have been—and what might be for future relationships."
—*Library Journal*